C000045916

London
Notebook

Images/drawings © Graham Byfield
Text © Roger Williams

© Editions Didier Millet
121 Telok Ayer Street #03-01
Singapore 068590

Designed by Lisa Damayanti

Printed in Singapore by Tien Wah Press

ISBN: 978-981-4385-81-7

www.edmbooks.com
www.leseditionsdupacifique.com

London
Notebook

Paintings by Graham Byfield

edm EDITIONS
DIDIER
MILLET

Personal data

Name :

Address :

Telephone :

Fax :

Mobile :

E-mail :

Work address :

Telephone :

Fax :

E-mail :

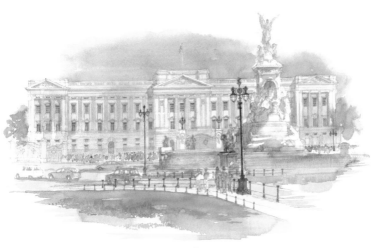

London

L ondon is the capital of a kingdom and of an empire on which the sun has long since set, but despite its changing role on the world stage, London's glory days are far from over. No other city has as many historic sites and visitor attractions, so it is little wonder that it is one of the most popular holiday destinations in the world.

Historically, it is a tale of two cities: the City of Westminster, where the monarchy and parliament are still based, and, around St Paul's Cathedral to the east, the City of London. Now the financial centre, the City, as it is known, is a square mile that fits roughly inside the walls of Roman Londinium. Linking them, and the whole city, is the Thames, the highway on which the city has prospered. A river trip is still one of the best ways to understand the layout of London, from the glorious Abbey at Westminster to the 11th-century Tower of London, and

perhaps on to maritime Greenwich, just one of the masterpieces by the 18th-century architect Sir Christopher Wren.

The glittering entertainment hub of the West End embraces the theatreland of Piccadilly Circus, the cinemas of Leicester Square, and the shops of Regent and Oxford streets and Covent Garden. At Trafalgar Square a statue of Lord Nelson (hero of the battle of Trafalgar, when the Royal Navy trounced Napoleon's navy) looks down Whitehall towards Parliament. Behind him is the National Gallery, one of the greatest repositories of Western art, and the National Portrait Gallery where Nelson, the most painted man of his day, puts in an appearance along with all the good and the great since the time of Elizabeth I and the English Renaissance. All of the major museums and galleries in London have free admission, including the British Museum, which is chock-full of antiquities, and a trio of magnificent museums in South Kensington showcasing science, natural history and, in the wonderfully eclectic Victoria and Albert Museum, the decorative arts.

The end of the Napoleonic Wars at the start of the 19th century heralded the Victorian age, the time of industrialisation and expansion

that made London such a Victorian-looking city, with monolithic stone buildings, abundant statues and a solid sense of itself. Buckingham Palace was by then the main royal residence, though Queen Victoria preferred life out of town, at Windsor. She had been born in Wren's Kensington Palace, where Princess Diana later

lived and now home to the heir apparent, Prince William, and the Duchess of Cambridge.

Kensington Palace's surrounding gardens, which extend into Hyde Park, a former royal hunting ground, are just one of many open spaces that allow the city deep breaths. St James's Park, another Royal Park, laid out in the 18th century beside Buckingham Palace, is the most attractive. Beside it, John Nash's 18th-century classical buildings stretch from Carlton Terrace up Regent Street to Regent's Park, where sounds of the jungle come from London Zoo. Beside the park, Regent's Canal heads to Camden Market, where more than a thousand shops and stalls attract fashionistas and bargain hunters every day.

London can be surveyed from a number of lofty spots, such as the London Eye, the big wheel on the South Bank, the city's liveliest promenade. This riverside walk passes the 1950s South Bank Centre, with its concert halls, the British Film Institute and National Theatre, to Tate Modern, Shakespeare's Globe Theatre, Sir Francis Drake's globe-roaming galleon, foodies' Borough Market and Southwark Cathedral, with an option to cross the footbridge over the River Thames to St Paul's Cathedral.

At the end, rising to unprecedented heights above Borough Market, is The Shard, the latest viewing point. From here is a panorama of all the exciting new skyscrapers in the City opposite: the Walkie Talkie, Helter Skelter, Cheese Grater and Gherkin, all dwarfing Wren's church spires and proclaiming a city that, like the river, keeps moving with the times.

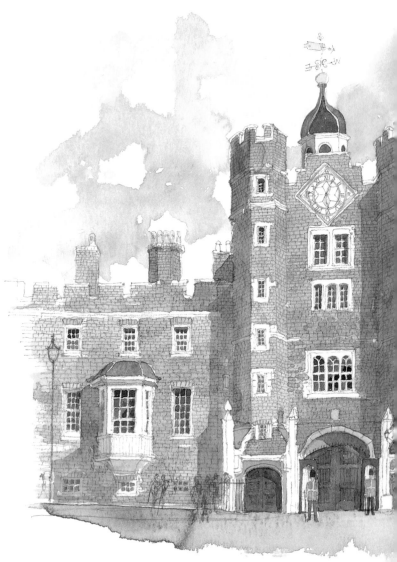

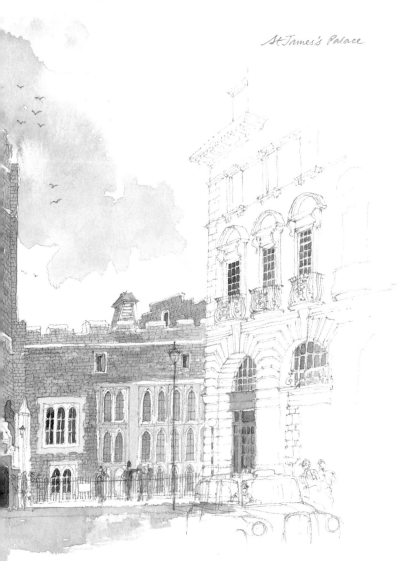

St James's Palace

London was amazing! Fantastic! I went with my family and my Manchester family.

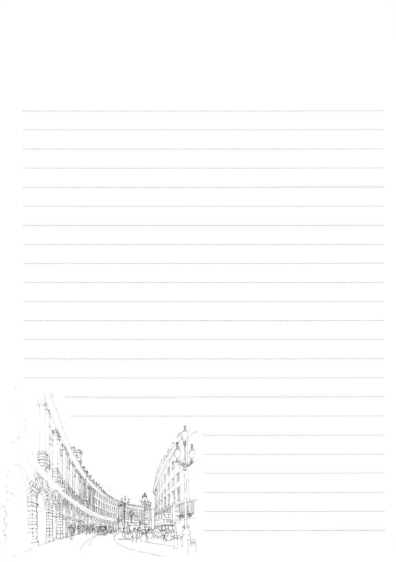

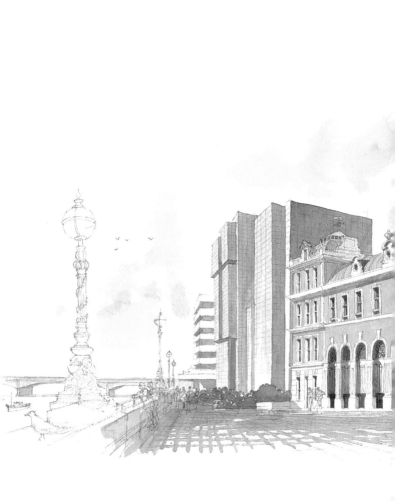

Billingsgate Market

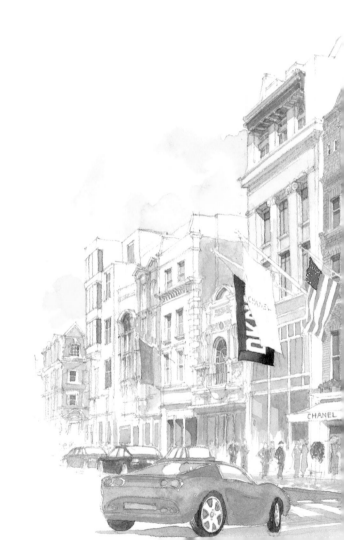

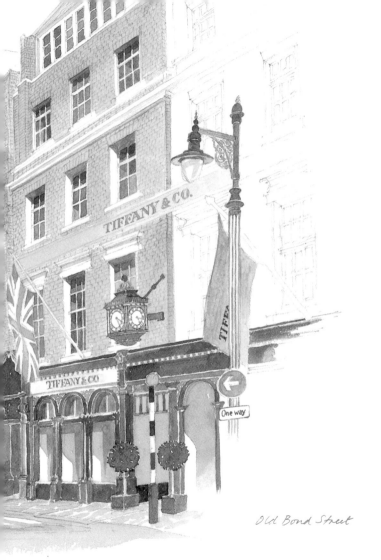

Old Bond Street

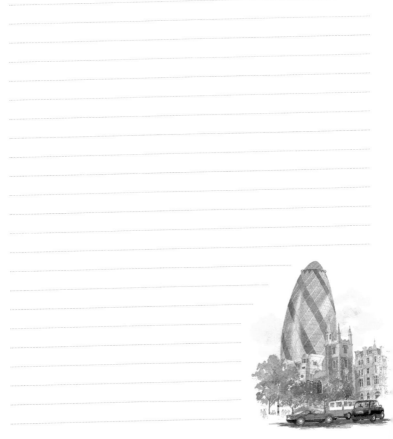

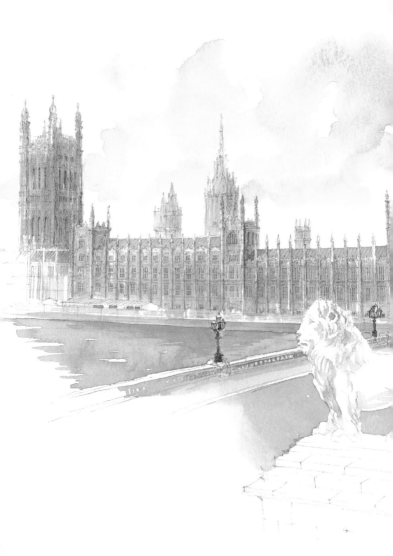

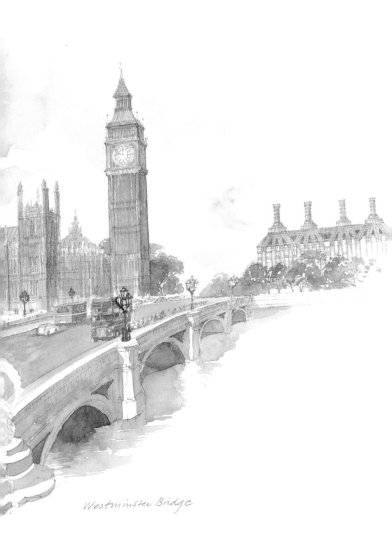

Westminster Bridge

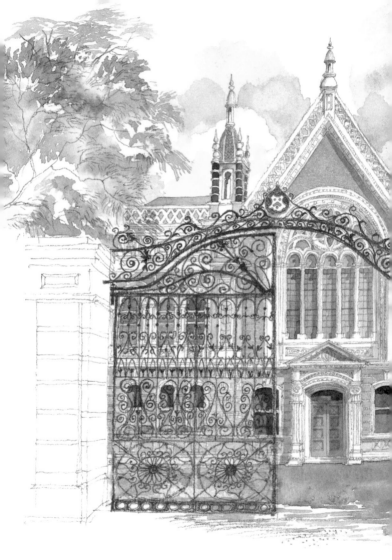

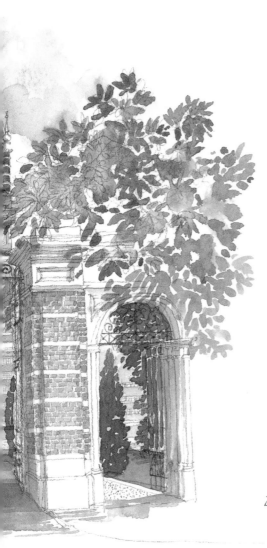

Dulwich College

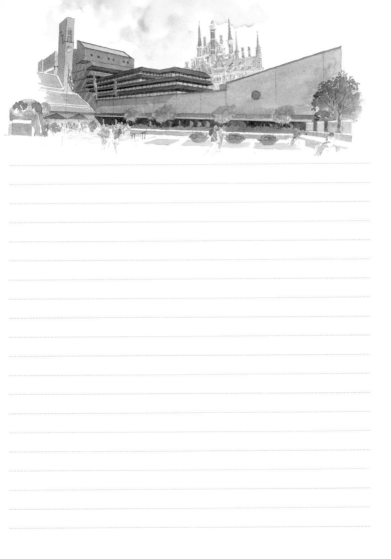

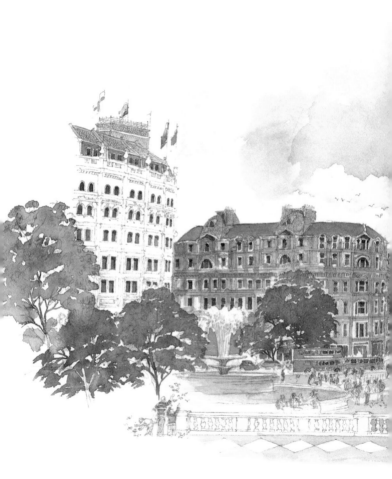

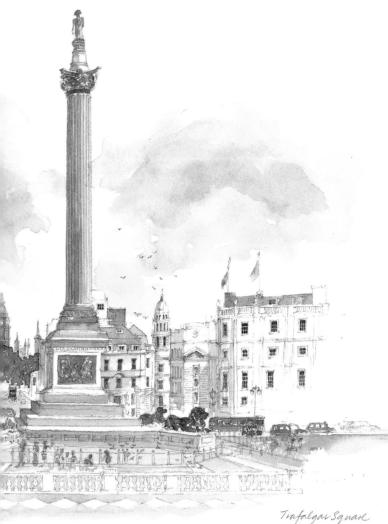

Trafalgar Square

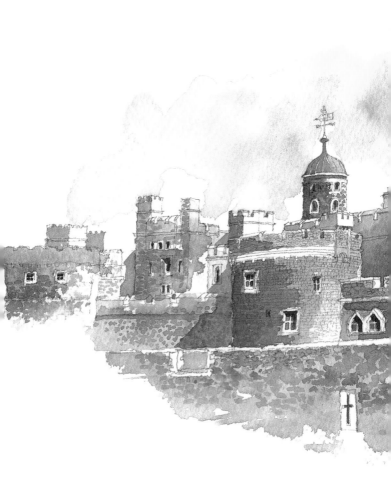

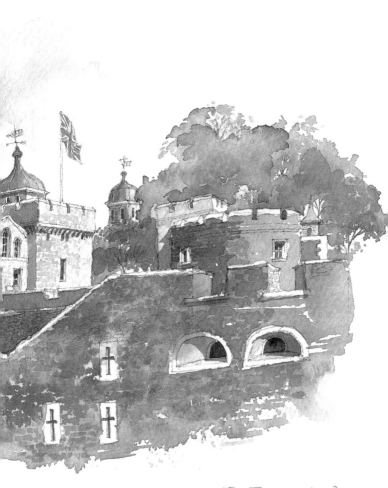

The Tower of London

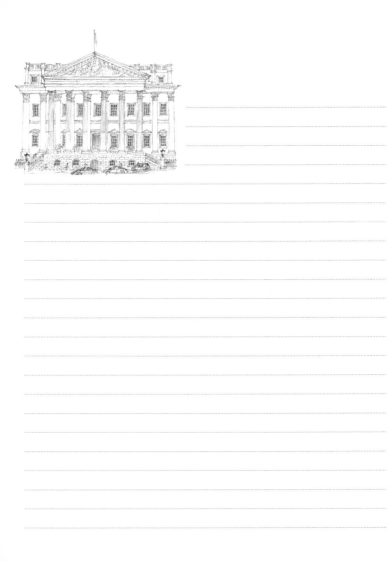

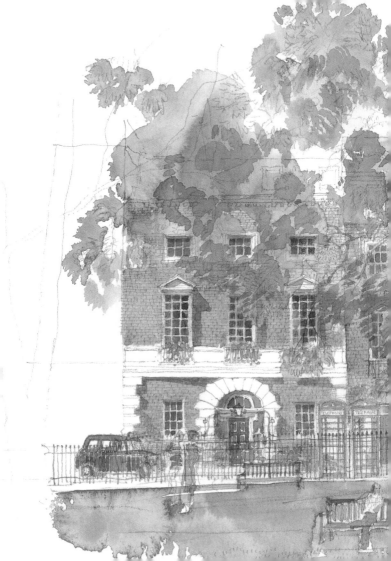

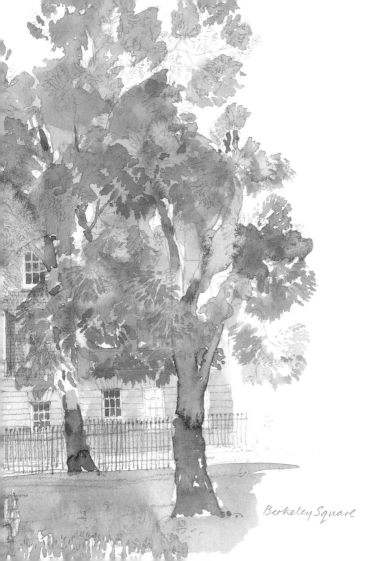

Berkeley Square

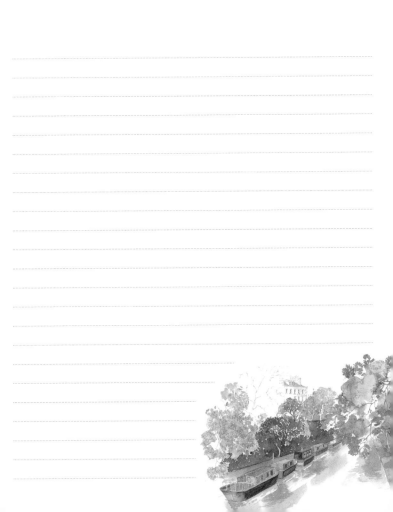

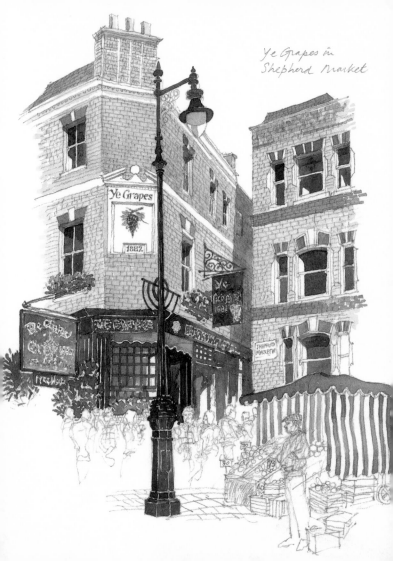

Ye Grapes in
Shepherd Market

2015

January

Mon	Tue	Wed	Thu	Fri	Sat	Sun
			1	2	3	4
5	6	7	8	9	10	11
12	13	14	15	16	17	18
19	20	21	22	23	24	25
26	27	28	29	30	31	

February

Mon	Tue	Wed	Thu	Fri	Sat	Sun
						1
2	3	4	5	6	7	8
9	10	11	12	13	14	15
16	17	18	19	20	21	22
23	24	25	26	27	28	

March

Mon	Tue	Wed	Thu	Fri	Sat	Sun
30	31					1
2	3	4	5	6	7	8
9	10	11	12	13	14	15
16	17	18	19	20	21	22
23	24	25	26	27	28	29

April

Mon	Tue	Wed	Thu	Fri	Sat	Sun
		1	2	3	4	5
6	7	8	9	10	11	12
13	14	15	16	17	18	19
20	21	22	23	24	25	26
27	28	29	30			

May

Mon	Tue	Wed	Thu	Fri	Sat	Sun
				1	2	3
4	5	6	7	8	9	10
11	12	13	14	15	16	17
18	19	20	21	22	23	24
25	26	27	28	29	30	31

June

Mon	Tue	Wed	Thu	Fri	Sat	Sun
1	2	3	4	5	6	7
8	9	10	11	12	13	14
15	16	17	18	19	20	21
22	23	24	25	26	27	28
29	30					

July

Mon	Tue	Wed	Thu	Fri	Sat	Sun
		1	2	3	4	5
6	7	8	9	10	11	12
13	14	15	16	17	18	19
20	21	22	23	24	25	26
27	28	29	30	31		

August

Mon	Tue	Wed	Thu	Fri	Sat	Sun
31					1	2
3	4	5	6	7	8	9
10	11	12	13	14	15	16
17	18	19	20	21	22	23
24	25	26	27	28	29	30

September

Mon	Tue	Wed	Thu	Fri	Sat	Sun
	1	2	3	4	5	6
7	8	9	10	11	12	13
14	15	16	17	18	19	20
21	22	23	24	25	26	27
28	29	30				

October

Mon	Tue	Wed	Thu	Fri	Sat	Sun
			1	2	3	4
5	6	7	8	9	10	11
12	13	14	15	16	17	18
19	20	21	22	23	24	25
26	27	28	29	30	31	

November

Mon	Tue	Wed	Thu	Fri	Sat	Sun
30						1
2	3	4	5	6	7	8
9	10	11	12	13	14	15
16	17	18	19	20	21	22
23	24	25	26	27	28	29

December

Mon	Tue	Wed	Thu	Fri	Sat	Sun
	1	2	3	4	5	6
7	8	9	10	11	12	13
14	15	16	17	18	19	20
21	22	23	24	25	26	27
28	29	30	31			

2016

January

Mon	Tue	Wed	Thu	Fri	Sat	Sun
				1	2	3
4	5	6	7	8	9	10
11	12	13	14	15	16	17
18	19	20	21	22	23	24
25	26	27	28	29	30	31

February

Mon	Tue	Wed	Thu	Fri	Sat	Sun
1	2	3	4	5	6	7
8	9	10	11	12	13	14
15	16	17	18	19	20	21
22	23	24	25	26	27	28
29						

March

Mon	Tue	Wed	Thu	Fri	Sat	Sun
	1	2	3	4	5	6
7	8	9	10	11	12	13
14	15	16	17	18	19	20
21	22	23	24	25	26	27
28	29	30	31			

April

Mon	Tue	Wed	Thu	Fri	Sat	Sun
				1	2	3
4	5	6	7	8	9	10
11	12	13	14	15	16	17
18	19	20	21	22	23	24
25	26	27	28	29	30	

May

Mon	Tue	Wed	Thu	Fri	Sat	Sun
30	31					1
2	3	4	5	6	7	8
9	10	11	12	13	14	15
16	17	18	19	20	21	22
23	24	25	26	27	28	29

June

Mon	Tue	Wed	Thu	Fri	Sat	Sun
		1	2	3	4	5
6	7	8	9	10	11	12
13	14	15	16	17	18	19
20	21	22	23	24	25	26
27	28	29	30			

July

Mon	Tue	Wed	Thu	Fri	Sat	Sun
				1	2	3
4	5	6	7	8	9	10
11	12	13	14	15	16	17
18	19	20	21	22	23	24
25	26	27	28	29	30	31

August

Mon	Tue	Wed	Thu	Fri	Sat	Sun
1	2	3	4	5	6	7
8	9	10	11	12	13	14
15	16	17	18	19	20	21
22	23	24	25	26	27	28
29	30	31				

September

Mon	Tue	Wed	Thu	Fri	Sat	Sun
			1	2	3	4
5	6	7	8	9	10	11
12	13	14	15	16	17	18
19	20	21	22	23	24	25
26	27	28	29	30		

October

Mon	Tue	Wed	Thu	Fri	Sat	Sun
31					1	2
3	4	5	6	7	8	9
10	11	12	13	14	15	16
17	18	19	20	21	22	23
24	25	26	27	28	29	30

November

Mon	Tue	Wed	Thu	Fri	Sat	Sun
	1	2	3	4	5	6
7	8	9	10	11	12	13
14	15	16	17	18	19	20
21	22	23	24	25	26	27
28	29	30				

December

Mon	Tue	Wed	Thu	Fri	Sat	Sun
			1	2	3	4
5	6	7	8	9	10	11
12	13	14	15	16	17	18
19	20	21	22	23	24	25
26	27	28	29	30	31	

2017

January

Mon	Tue	Wed	Thu	Fri	Sat	Sun
30	31					1
2	3	4	5	6	7	8
9	10	11	12	13	14	15
16	17	18	19	20	21	22
23	24	25	26	27	28	29

February

Mon	Tue	Wed	Thu	Fri	Sat	Sun
		1	2	3	4	5
6	7	8	9	10	11	12
13	14	15	16	17	18	19
20	21	22	23	24	25	26
27	28					

March

Mon	Tue	Wed	Thu	Fri	Sat	Sun
		1	2	3	4	5
6	7	8	9	10	11	12
13	14	15	16	17	18	19
20	21	22	23	24	25	26
27	28	29	30	31		

April

Mon	Tue	Wed	Thu	Fri	Sat	Sun
					1	2
3	4	5	6	7	8	9
10	11	12	13	14	15	16
17	18	19	20	21	22	23
24	25	26	27	28	29	30

May

Mon	Tue	Wed	Thu	Fri	Sat	Sun
1	2	3	4	5	6	7
8	9	10	11	12	13	14
15	16	17	18	19	20	21
22	23	24	25	26	27	28
29	30	31				

June

Mon	Tue	Wed	Thu	Fri	Sat	Sun
			1	2	3	4
5	6	7	8	9	10	11
12	13	14	15	16	17	18
19	20	21	22	23	24	25
26	27	28	29	30		

July

Mon	Tue	Wed	Thu	Fri	Sat	Sun
31					1	2
3	4	5	6	7	8	9
10	11	12	13	14	15	16
17	18	19	20	21	22	23
24	25	26	27	28	29	30

August

Mon	Tue	Wed	Thu	Fri	Sat	Sun
	1	2	3	4	5	6
7	8	9	10	11	12	13
14	15	16	17	18	19	20
21	22	23	24	25	26	27
28	29	30	31			

September

Mon	Tue	Wed	Thu	Fri	Sat	Sun
				1	2	3
4	5	6	7	8	9	10
11	12	13	14	15	16	17
18	19	20	21	22	23	24
25	26	27	28	29	30	

October

Mon	Tue	Wed	Thu	Fri	Sat	Sun
30	31					1
2	3	4	5	6	7	8
9	10	11	12	13	14	15
16	17	18	19	20	21	22
23	24	25	26	27	28	29

November

Mon	Tue	Wed	Thu	Fri	Sat	Sun
		1	2	3	4	5
6	7	8	9	10	11	12
13	14	15	16	17	18	19
20	21	22	23	24	25	26
27	28	29	30			

December

Mon	Tue	Wed	Thu	Fri	Sat	Sun
				1	2	3
4	5	6	7	8	9	10
11	12	13	14	15	16	17
18	19	20	21	22	23	24
25	26	27	28	29	30	31

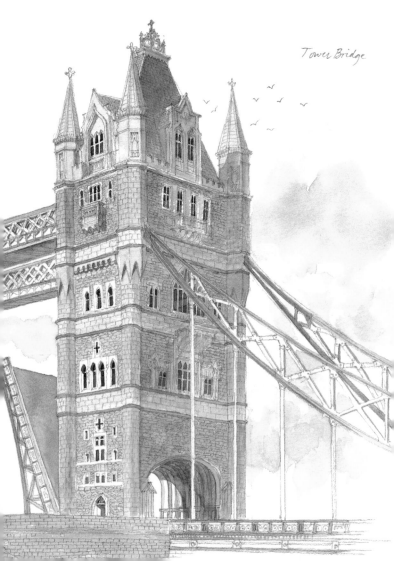

Tower Bridge

London at a glance

Official name: London
Country: Great Britain
Location: Southwest England
Coordinates: 51°30'26"N 0°7'39"W
Land area: 1,572.00 sq km (606.95 sq mi)
Population: Approx 8.3 million in the city, 15 million in the metropolitan area
Number of boroughs: 32, not including the City of London ("The Square Mile")
Main religion: Christianity
Language spoken: English
Currency: British Pound
Demonym: Londoner
Time zone: GMT (UTC±0)
International dialling code: +44-20
Airports: Heathrow, Gatwick, Stanstead, Luton, London City
UNESCO World Heritage Sites: Tower of London; the Royal Botanic Gardens at Kew; The Palace of Westminster, including St Margaret's Westminster and Westminster Abbey; and Maritime Greenwich
Fun things to do: Visit the British Museum, ride on the London Eye, Madame Tussauds, tour the Tower of London, watch Changing of the Guard at Buckingham Palace, shop at Harrods or Borough Market
Famous literature set in London: *Oliver Twist* (Charles Dickens), *The Strange Case of Dr Jekyll and Mr Hyde* (Robert Louis Stevenson), *Brick Lane* (Monica Ali), *About a Boy* (Nick Hornby)
Website: visitlondon.com

The watercolours of Graham Byfield, which illustrate this notebook, have been published by Editions Didier Millet in *London Sketchbook*.

Other titles in this series:

ARTIST **Graham Byfield**
Amsterdam Sketchbook
Bahamas Sketchbook
Bali Sketchbook
Oxford Sketchbook
Singapore Sketchbook

ARTIST **A. Kasim Abas**
Sarawak Sketchbook

ARTIST **Chin Kon Yit**
Kuala Lumpur: A Sketchbook
Landmarks of Malaysia
Landmarks of Perak (with
A. Kasim Abas and Huai-yan Chang)
Landmarks of Selangor
Malacca Sketchbook
Penang Sketchbook

ARTIST **Sophie Ladame**
Mauritius Sketchbook

ARTIST **Fabrice Moireau**
Gardens of Paris Sketchbook
Loire Valley Sketchbook
New York Sketchbook
Paris Sketchbook
Provence Sketchbook
Rooftops of Paris
Rome Sketchbook
Venice Sketchbook

ARTIST **Taveepong Limapornvanich**
Thailand Sketchbook

For more information please log on to: www.edmbooks.com

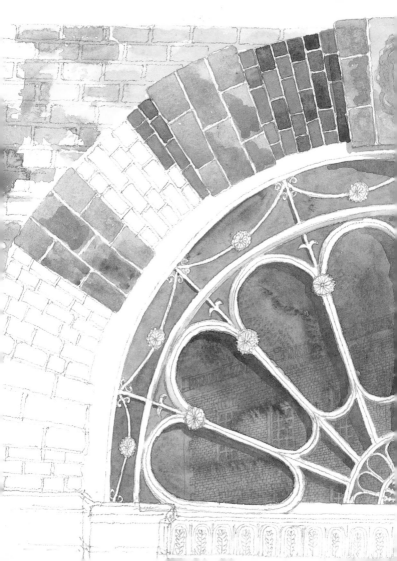